HALF
ANGEL,
HALF
LUNCH

HALF ANGEL, HALF LUNCH

Double Scorpio!

Sharon Mesmer

Sharon xo

lingo books

HARD PRESS, INC. 1998

Some of these poems have appeared in the following publications: *New American Writing, Exquisite Corpse, New Observations, Appearances, Red Tape, Downtown, Semiotext(e) USA, Intro 12, Telephone, Hanging Loose, Brooklyn Review, Hair Trigger, Blue Unicorn, The National Poetry Magazine of the Lower East Side, The Nice Review, BoogLit, B City, Red Weather, Another Chicago Magazine, Blind Alleys, Lucky Star, Joe Soap's Canoe, Beet, Pink Pages, Tomorrow, Oink!, The World.*

"Eleusis" appeared in *Unbearables* (Autonomedia); "Chicago" appeared in *The Stiffest of the Corpse: An Exquisite Corpse Anthology* (City Lights); "The End," "Self-Confidence," "Superficial Voltage," "Ed Goes the Way of All Flesh," "Little Queenie," and "Sally Silver" appeared in *A Reasonable Affliction: 1001 Love Poems (Black Dog & Leventhal).*

With love to David Borchart,
and with gratitude to
Paul Hoover, Randy Albers, Alice Notley,
Larry Fagin, Maureen Owen, Michael Gizzi, Ron Kolm,
Jordan Zinovich, and Allen Ginsberg.

In memory of Arnie Rubin, 1949-1979.

Contents

"Basically, everybody's half angel, half lunch."

—Ted Berrigan

THE WENCH IS WILLING

I seem more beautiful than I am because no one's ever seen me clearly.
My powerful bosom is a grandiose vibration of molecules resembling
lettuce. My legs go from here to the next car in this section of the
parking lot. I am brilliant without imagination, medication, or
sentiment. I work best in the gap between art and life, eliminating
odors. I got my start in Barking as an orchidy matron purling. Now I
am a quartet of housewives wiping their hands on floral aprons
outside the cap factory, I am the front room of a filthy third-floor den-
tist office in 1945 where Dr. Lack, nickname "Fister Junior," controls
the flow of all Life with a big black transmitter. You have caught me
with my bloom of youth down, sis, and I am frothy as an orchard, I am
a handful and a half, I am Miss Charlotte Banister, whom the butcher
boys all call "The Blitz."

THE ORIGINS OF MY INDIVIDUALITY

Without the warmth of the working classes, the influence of anxiety, the thoughts that lie too deep for tears as sung by Barry White, without my successful emergence from the orphanages of industrial Hungary, my stormy adolescence in Milwaukee, the amphitheatre atmosphere of my dotage, without seeming like some intellectual, or anti-intellectual, neither droll nor prole, without the use of the new neutrals as suggested by the doyenne of WASP housekeeping, without the avant-garde etc., without arcane architectonics, textiles and musicals, or a prose coquettishly embroidered yet recalcitrant, made up of sentences formed in sleep, without having to constantly worry about losing the greatest fuck of my life — my mother, strolling through a moonlit grove in her native Poland — without having to fake yet another orgasm, and purchase expensive over-the-counter yeast infection remedies, without you forcing me to endure the company of painfully beautiful women, and without it seeming like I'm talking to you because you're suddenly famous when really I find your new self-righteousness incredibly annoying and pretentious, without the renewed threat of parthenogenesis, and that endless Elton John song, without another weekend of everybody fucking and fighting, without using as much ink as Euripides, and without you, youthless Andalusian, without whom I can't live if living is without: only love can make it rain.

Desire Seeks What Has Been Lost Forever

In the beginning God created, and there was light, and the Hebrides. And in their aspect we ate and drank, and in their wake we died. And with a thread we bound the Pleiades and loosed Orion's bands.

And then a wind came, full of sea, moving above the Hebrides. On the darkness moving, on the face of the waters moving, like ravens moving with a sound like rain, and the Hebrides disappeared, and cut us off from the lands of the living. And thorns grew among the fortresses, and deserts rose from the oceans, and we bore out our sorrows watching from the perimeters. And like Ancients of Days the Hebrides brooded, prophesying our songs to bones.

And the gods of sleep and healing brought every thing to living: the art of true forgetfulness, and the memory of a beauty greatly feared.

And still we keep our night watches under shadows of stars long faded. Turn us loose on your great western gateway, oh Hebrides: let us live again.

THE HAIRY MAN

The village is situated on a foggy peninsula where the sun never shines. Beyond the fortification wall a forest grows and a monastery rises from a ridge. There is speculation among the woodsmen as to whether the monastery is occupied — they claim to have once seen a figure whom they believe to be the Hairy Man pacing the parapet When the Hairy Man naps in his hut below the ridge, the village becomes an arena for his dreams: a sleigh appears in the sky, dropping animals and naked women. And when the Hairy Man has a nightmare, the mayor dispatches his watchers to the walls.

THE BEAUTIFUL PRINCESS WITH ONE EYE

Her eyebrow a suggestion, after the fashion of the time. The pale peak of the almond curve, the lag at its conclusion: results of her customary languor. Siena when her eyes brighten, muddy when they blacken, and a light, a tiny star, pointing toward the tendrils falling from her low forehead. Her hair parted high at the crown.

The Terrible Life Of The Goose

Scumbled, petted, smeared and rouged: young girl with a broom.

TWIN

In a red desert you run toward me with your hands held out, crying, "I'm so beautiful!" As I grab hold of your shoulders you disintegrate into pale papery fruits which I toss into the air, and they shower down, sparking like stars. Then the red sky fades to gray, the apricot clouds ripple to indigo, and huge steeples of sand rise from the scattered fragments of you.

MEMORARE

The elevator doors close on your silence. Across the hall, the elevator doors close on my silence, too. You're crying, wearing my sister's wig, sad because my silence hasn't called. The tall man behind you looks down at your silence, and you nudge him and point at me, as if to say, "There it is: that's her silence." The doors close on both our silences; we'll never see each other again. All the glasses you brought me last summer from Munich are broken, the glasses that were blue, bavarian, like our silence.

CUBAN WATER

Norma is pulling me up, her brown hand on my white wrist. The black and white floor has grains of sand scattered on it, one after another, and swirls too, like brushed on. I don't want to get caught in the swirls, so when she yells, Just Look Up! Look Up At The Water! and people yell, Look Up! I try, it takes a long time, Norma puts her hand on my chin and pulls me up.

It's the water, wide blue Cuban water, going out in all directions, millions of people below, slow, and the high white sky, a sleeping giant.

ON MAN IN THE UNIVERSE

Gray, almost white, almost snow, and a black bowl opens beneath the perimeter. Two hawks cross the Bosporus; the empire of pink is attenuating. Packed and cramping, we pray to purify all we will deliver. There's a solution missing. It comes when my father is forced to drive quickly to avoid a tornado: he has a heart attack and a telephone pops out from under the hood of the Rambler. We pass our hands over our satchels, pour forth our delectation upon the altar in sacrifice. The presence of lochial blood eats the air. Clusters of young stars anticipate apocalypse. The only thing left is to have faith.

GERMANS

A Circle Liner ploughs through the lounge window, sending water crashing everywhere. Terrified, we remain seated as calls for calm from the captain sound over the intercom. I take control of the family, telling them to stay together as the crew herds us onto shiny red rafts. Buoyed by choppy water, we wave at our damaged ship in its huge holding structure. On shore, beggars waylay us, thinking we're Germans.

CAFE ENNUI

a suite of seven poems

Are we the results of some bizarre narration
of the pleasure principle?
Are we versions of desire, but not desire itself?
Do you often find yourself awash in these vague ideas?
Then nip it in a budding grove.
You should be able by now to discern the good from the stupid.
If not, what you really need is vodka. Vodka. Polish vodka,
& the 99 sacred and profane versions of "Louie, Louie."
As for me, what I don't understand I will loathe,
and what I loathe I will fuck.

Whence does it come and whither will it go:
from sabachtani to saxophone,
abracadabra to drone,
graduation day at the Cashier Training Institute.
Undulant, peach-like hips,
lucent
like the powerful approach of spring,
august gestures of torment and rapture
through the last metallic moments
of a passion Woolworth red.
My Heraclitean double motion:
I deliver it hard and fast,
words loud and square
from round red lips.

Excuse me if I sound like the ancient mariner, I said,
but I was raised Catholic.
The tragic edge of my nature opens naturally into poetry, she said.
Tragedy and bar rooms seem to go together somehow, I said,
like a wrinkle in the skin of transition.
No longer artist, she said, I am now a work of art.
I will write a happy girl poem, I said,
made up mostly of affectation as I am.
White people danced badly
to Motown in the next room,
and like the red lily erupting from thistle,
she curved radiant painless and clear,
though her fruitcage
produced nothing, consumed everything, wanted anything.

Your attempts to escape the crepuscular glow
of your liberal tenement
were funny because you were
really feeding on it.
Spare me, asshole.
Your oedipal zoo wrings my heart like a rag of tears.
Your friendship is as welcome as a malignant itch.
Your hankering for the idyllic is churlish,
a flurry of slender adagios.
For you, young citizen of poetry,
suicide is the soup de jour,
a kansas city of the mind.
May it lead you not into the collective unconscious,
but deliver you from the will to power.

Some moonstruck gorilla hefts a basket of bad sonnets.
He craves a belief in the primordial existence of the Sensitive Guy.
He is abject, bereft, and derelict; fetal, bovine, and excremental.
He's sick of living but sicker of dying cold and slow.
The words from his living trenchmouth make our Latin richer,
slide greasily into poetry.
Fetal star,
yours is the noble and eternal silence of Ajax in the Underworld.
But no one cares about you, mediocre poet.
No one wants your sucking up to illusion, pretense and poverty.
The verbena dream of your Santeria second-hand store
is intoxicating,
is sweeter than the memory of your arondissement,
where everything mortal was beautiful and vibrating with death.

Once you recognize yourself
in the primitive
you can jettison the fabula
of your dubious achievements.
Once you recognize how the cult of memory
invades the universal problematic,
every egyptian moment is translated through you.
But where can you go after such vigorous boasting?
It's disturbing to fuck someone so absolutely negative
their nocturnal emissions form a silhouette of Elvis.
Scientists peer to the edge of the universe and are astounded.
It ain't no sin to be glad you're alive, didn't Byron take
a monkey to Europe?

The riddles and contradictions of the original Oneness.
The painful reverberations of the Image.
Memory and its lattice of troubles.
Hopefully I'm dead and just haven't been notified yet.
I feel this poem wants to be rid of the poet.
Its goal is tranquillity,
to lie down swiftly and remain supine,
to achieve a hierarchy of joy by slow degrees.
Ah, luxuriant and triumphant existence.
At dusk the purple papers glow.
Let us lament and black out together.
Let us go through scum.

SALLY SILVER

Pale slope of nape and neckbone
Icy jut of jaw and cheekbone
Odor of two nights ago:
Sally Silver, smooth as sable.

Hand mirror and trousseau
Traveling pretty picture show
A word from silence
A cloud of dust
(a salty dog she can count on):
Sally Silver, sad as silk.

Let's play the radio till the curtains rot
Let's rock in the sand till the horses run
Let's rise like fog.

Voice of blue-green forest morning
Once more in the middle of winter
Stars give birth inside her belly:
Sally Silver, cool as milk.

Fata Morgana

Sahara-dark and dry-skinned girl:
birth of grease and brilliantine;
her mother a keeper of copious masks,
always toiling for the sublime.

Sahara-dark and blue glass girl:
profane wish for whiteness;
nostalgia for dreams eliminates distance,
the memory of steam and hunger,

the much-hunger of his haunches,
the saucy lozenge of his armpit;
the little roughneck saddles up
a psychology of faith and fear.

She is his archer and his emerald,
false spring and damp hammer,
breath of eden; abyssinia,
thing that tastes best at 3 a.m.,

ruptured bug-eyed and barely breathing,
kneading with her sweat and sighs
the sleep preceding death,
the rising of the dog star.

Sahara-dark and gelded girl:
gesture fallen from a caravan;
a heart that is cracked across
breath after breath of sahara,
dark and dry-skinned,
blue glass girl.

LITTLE QUEENIE

Dirt-dark she was,
a beast of burden,
looming large and nurse-like
in my garden.
The autumn leaves fell
like a gentle rain;
I told her I loved her,
she said, "Tell me again."

Little Queenie she was,
cheap clothes and roses,
she smelled like a church,
she had valentine poses.
My pious bones were broken
like a waiting slave's;
she said, "You ain't no white angel
but you sure are brave."

She ruined my roof
but now I'm drowning in light;
she broke my boat
but I drifted upstream;
I'm so drunk in this world there's no
tale to tell;
she said, "Once you leave me
you'll be an angel."

Transition's skin
is so transparent:
kerosene colors in a tall glass furnace.
Like Penelope I'm waiting

on her pure war love,
on a bare white bed
under a bare light bulb.

TAKING UP SPACE WITH VIVIAN

He's taking up space with Vivian,
sharing the same space she's living in.
He's taking up space with Vivian,
every post meridian.

Every post meridian,
he's rearing children with Miriam.
Dwelling his days in delirium,
he's rearing children with Miriam.

He's vying with Victor for Vera.
He's buying mirrors for Vivian.
Hiding the hole that it's mirroring,
he's smearing his mirrors with Miriam.

THE ROSE OF SHARON

is hominy
is homebound
is lulling dulcet nocturne
is boiling lobster with a black eye at the annual family wing-ding

is andalusian bordello portrait
dime store gut bucket
is azore and ozark, secret green continent, awaiting the riot
 of boys at the gate

is memory: a dangerous angel
a fuck for the first day of summer
is blue pearl-grey like mother of pearl,
clear pink rose

is pony: going down behind the ballroom: hips of fierce
 skinny-lipped boy
glossy cherry O-mouth in the bowling alley bathroom
(her puerto rican kingpin plays foosball in the half light)

in the kitchen's trance no raptures
in torn t-shirt and dirty bra, fatherless in the dark,
in smoke/cold/the radio:
ankle birthmark where the wings were

silver blade dips her wrist
flies whirl in a golden shithouse sunbeam
diaphanous sham, she reclines on a couch:
bluestocking, but never blue
splinter from the floor she was born on

is waiting at the lake (is waiting)
promiscuity and legionnaire's disease (is waiting)
tough as a 69 cent steak and waiting for Mr. Wrong
is waiting

is the uterus in question
the ennui in ingenue

is poised for the penthouse a big big youth
trickiest elixir: potion of slathered mandible
poetry of who you screw

feeling full moon in Scorpio, meaty fist of dumb policeman
shoved up her oily cunt
feeling flaming June's beatitude: waking late with strings of come
 tangled in her long black hair

is pissing in your flaccid handshake
is sleeping in your station wagon
not waving good-bye but drowning,
is playing your hair like a harp

ED GOES THE WAY OF ALL FLESH

Jealousy, lend me your ear,
your ear
of crime and crucifixes.
And lend me your jealousy,
Ed,
Ed, lend me your arena boots
and broken bones,
your suicides set in Italy,
your evasive action
which follows passion.
Ed,
your greasy luck.

I first saw you in the parade of
pick-up men, whispering,
"Let's make this Uptown."
I next saw you in the gallery
with your torso
and family.
Then I saw you selling girlskins
by the side of the road—her severed head:
omen of quarrels and remorse.
And now your brain is on me like a bad song,
and your smell is in me like a tomb,
and true love is upon you,
Ed,
like an ill-fitting suit.

You are making swains
of my old dead lovers, lurking
in the luck of death, feasting

on its flank,
without your soul, without your shirt.

I dreamt I pissed on your playing cards,
I dreamt you were the company whore,
I dreamt you were the long tall Sally,
the mustang sally, the fire
of unknown origin,
milling in my milieu
swilling in my swarm,
my malaise enflamed,
born blue
with a parlour mark,
Ed.

INDIGO

It's Sunday,
and I see Indigo:
waving from the chop suey restaurant,
she is weaving worm's eye and breathless,
breathless in Time's Square.
It's Monday,
and I see Indigo:
beside herself in the world of beauty,
she is the blondest blonde in the balance dance,
a rack of enchantments.

Here comes Siberia,
and there goes Indigo,
and it is Tuesday,
and a big boy in a blue suit straightens his back
and tells me fifty facts about his aura,
and what vegetables will improve my hair.
But this is just a brief gaudy hour
when someone always seems to say,
"women who crave men
 wanna love cave men,"
and this is envy like a child's.

And next it is a Wednesday night
when I see Indigo,
and it's league night at the Miami Bowl,
and Tessie wins the candlelight,
and for an hour she is the layabout in the limelight,
and then it's back to the homebound housemother,
and she sees Indigo too.

When it's Thursday,
and drama creates bondage,
and familiarity breeds contempt,
I see Indigo.
I see Indigo
and Indigo sees women, and the women see men,
and the men see everybody,
and they rush out after their homemade
I-See-Indigo Dolls,
and Indigo thinks,
"From desire to revulsion. . .
 let's just get it over with!"

And then it's Friday,
and where is Indigo?
All summer drinking whiskey sours under a pink light,
practicing melodramatic mentalism,
and the true art of forgetfulness.
And then it's Saturday,
and my heart is rented out till winter,
and my lassitude is left behind,
and I see departures in affections, and shining sounds,
and I see Indigo.

NADA

and on the first day
a fragment of the true cross
is etched into the breast
of Nada: the thing in her heart
a circle of stars
stark above the carnival:
and a young girl on an old man's arm
and the hands of a man on her neck
nestling
towards the weakest of human affections,
and the long fingers held in calm assurance
in the grassy lap
of Nada: guest and prisoner of the earth
caressing towards the bath of light
in the hot, half-forgotten country
of Nada: where the fossils of her language,
like lemmings, bide their time
poised to shining seas
poised at the well-born soul of death
death dreaming her dreaming me
dreaming her
legs:
a parentheses
a falling showering
of Nada: of st. john and his prayers:
appassionata: dolorosa, immaculata
her hands her eyes mouth and tongue
face down on the freeway
dreaming her bloodstream streaming
dreaming Nada: the desire the thing in her heart
that clouds the memory of

passion: sad, immaculate,
the accidental condition
the brittle and wintry landscape of enchantment
a whole epoch sewn with stars
with the burning star
of Nada: beautiful human girl
 who must *not* die.

for alice notley

PASSIVE WOMANHOOD PLANET

make me twisting sandstorm.
little fat starling.
i've got that smell of your water,
i've got that sidewalk far away.
clairvoyant in bath i am
egyptian to the ears.
i see women turning pages,
crisp jesus books.

make me isolate brainstorm.
all alone with a. . .
yeah, you know,
alone with a photo:
frozen you in trees and beach,
frozen wet dumb and sweet,
that's what i want
that's what
that's what i want.
her european eyes periscope,
and i only squat back to back,
waiting for the game to start.

make me american swivel redhead.
classic face piercing and serene as rainforest.
because i am smitten over slow centuries,
because of long hues over egypt,
i see women:
alone and leggy,
chin on knees, baroque harness,
and later cold and oblong between garish ceiling
and dirty sheet pulp,

nervous as tendrils. . .
and what am i?
what do i want?
no sidelong glances,
no finding it in the drawer,
south to sun
in plastic laminated,
these fierce stars must roll out,
and quiet is quiet
with no dishes.

SUPERFICIAL VOLTAGE

You are sick of this museum.
Tired of the restless lap at last.

You are finally quiet,
finally the child that your parents desired for thirty years,
finally blossoming at the bar mitzvah that is neverending
until Cleveland,
or in the last turning off of that bare bulb behind the old Jewish
clothing store.

You are elemental now,
definitive and invisible as algebra,
gone back to sand and air and aqua.
Your life is worthless now,
nothing more than the low, blue flame that prevents
a primitive death.

Your bent back (embarrassing, for a young man)
was a mismatched barrel of bones,
staggered as the skyline,
your black hair a dusty, mis-cut pyramid.
Your smell was leather in a small foreign car,
soft dirty beds, and shirts hung from drawers like spanish moss.
And when you left, that smell hung in the ransacked record store
for days, as if you could still be waiting in the backroom,
a patron saint of hunchbacks,
sending out Life through a great black transmitter.

Your last season was rouged nipples under a cheap nautical shirt;
the carpet of pornography;
the mother with the restraining order;

a lying palmist in a shopping mall,
predicting future fist gifts.

You were the ancient, land-loving Jew who guards his sex
like a warm, wet pearl,
the rickety kitchen, the absence of the phone not ringing
and heel-rubbing on the folding chair
at the biggest dance of the year;
you were blue tv Sunday nights,
feeling sick under the Magi-kist sign,
winter pregnancies
and a tragic orange in Washington Square.

You were the big box that arrived every birthday.
Your death, a kiss stolen in a sportscar.

THE ANGER OF ANIMALS

Asleep between the eyes of men,
just at the moment when girls give up rough games,
I don't want cages, furniture, flowers,
but rather the things we carve from shadows.
Last night I dreamt I was a man,
and stars were bursting beneath the house.
In trying to defend ourselves we are subtle;
we seem to fly though we weigh ourselves down.
I remember the night you waltzed naked around the bed,
and the lump in your heart turned to sound.

Suddenly you hear a cry from miles away,
then a roar from a silly saviour ship called "True Love."
Two loves not enough so
you exercise your mind with gymnastic fantasies.
But I won't rub my dry feathers to fire,
or flit around your wrist to be forgiven.
See — I am already drowning in a look.

A few lions remain —
their whole universe a weight too heavy to bear.
They have since rejected man's sympathetic systems.
I think of the light that opened over me the first morning,
I think farewell to furnitures, to flowers,
and obedience to artificial rules
upsetting me with sudden claws and tongues and colors.
Then a man steps up, saying, "I demand Aladdin."

The anger of animals takes up half the space,
as when a man goes down deep into his dream,
already expecting his next step to be a fall.

The anger of animals conjures up new devices:
they know well that only the moon invents aprils for the flesh.
Since Christmas they have lived with us,
their eyes shining like warning tower lights,
their thoughts breaking a tree down into doubts,
their cold breath like the first floodwaters to
reach our windows.

They devise elaborate epitaphs for dying mobsters,
invent new drugs for realism,
and acknowledge some of the most brilliant arrays
of exterminators: farewell to sizes and colors
raised against the faithful prohibition of death.

JAYNE MANSFIELD'S HEAD

It was not a gruesome sight,
and I thought mainly of last minute lists.

What a nice slice of life to be riding with blonde hair blowing,
spread out,
the dull smile brighter than the blue brain.
No time to contemplate the bills,
or the men who draw the drapes in hotels.
No time to scour the promises that grow stale and submissive
with each successive gin.
Never enough time to wriggle free of full moons and clear,
cloud-heavy days.

So you comb your hair like you hang your drapes:
anxiety in the shower.
All men crave that distant wave from the rocks,
a hand going up from the eddies,
pink and protestant,
or a young wifey in a white nightgown,
collapsing into a clothesline on the sweet, clean lawn.

You and he were riding in a car, an older man,
yellow with indecision.
Maybe you were being coy, or catty, or just trying to think.
But I don't raise an eyebrow, I just watch the movie,
exulted by mythology.

SELF-CONFIDENCE

I have forsaken thoughts of watching clocks,
and groping blindly for phones at ungodly hours.
It is time to search for shop-keepers,
proudly unrolling red and white canopies,
time to sit on the fire escape in the red fog,
and *not* blubber
so that my tongue becomes thick as gum,
and I pull frantically in my half-sleep to free it.
Something must be done.
My former intention was to be a movie star,
but you say I was born in the wrong era:
I should have been 35 years old in the '50's,
with stiff blonde hair stouter than a muscleman,
and gotten picked up in bars by gas station attendants
while I reapply lipstick (a shade called "Rich Girl Red")
and reapply it again and again.
And again.
I may also have been born in the wrong country:
I should smoke Gitanes and run my thumb across my lips,
loosen your black tie on crowded downtown streets,
while clutching a bottle of Chanel.
Yes, it's a circus.
My glove is in the garden . . . get it.
There's a fire on the floor . . . find it.
Please come in wearing my beret and your camel coat,
I really don't care where you bought it.

Rules For Etiquette At A Posh Party, Which You Attend Alone

You will sail through the big doors and you
will let your eyes roll up,
acknowledging the poets embedded in the dome,
following listlessly the hypnotic rise and fall of conversation,
conscious of your pretty ankles,
and your waist which glides and you
will extend slowly,
wrap your fingers around a drink,
a clear drink,
that titters when the ice is stirred,
and facing the symphony
you will pass them seductively,
concentrating on the cellist,
the invention of a clever mentor,
letting your eye linger past your body and you
will stand by a window
as if on a balcony,
lounging over the skyline,
your hands gripping the railing,
your legs crossed at the ankle and you
will descend the wide stairs in the center,
and outside call a cab,
while standing alone and white in the middle of downtown,
the neon on the side streets winking,
the main street sedate,
and sit in the back seat like a movie star and you
once home,
will remove your skirt,
let it fall on a soft heap to the floor,
and your blouse,

loosely,
on top of the skirt,
and peel off hosiery,
and shoes,
and you
will lie on sheets,
fall asleep,
and dream of me
dreaming you.

Love Is a Many-Splendored Thing, In Brooklyn

She's a whitegirl dancing braless in his teenage basement bedroom
He's a whey-faced Polack with his tonsils in a bottle.
She's planning to seduce him on the Staten Island Ferry.
He's marrow-close and loaded with his first true kiss.

She thinks, "You're nobody till you remind somebody of their mother."
He just wants to go to Bombay and be alone.
She just wants a few near-death experiences.
He's hungry for a passion bitter and damp as a last cigarette.

She first saw him masturbating off the Brooklyn Bridge on Easter.
He first saw her face down on Christmas Day, repeating,
 "Don't I know you from Kuwait?"
She imagined him blonde and bovine between the stale sheets of a
 Times Square Hotel.
He imagined his next confession.

He invited her over for some chicken pot pie.
He lived on Dire Avenue, the Bronx.
A plastic St. Anthony stood on the lawn.
His mother was on the phone with her sister Rosetta.

He had a low I.Q. but figured he could hide it.
His parents being cousins was what caused it.
Someone once told him his dull look was sexy.
He thought he'd be smart to talk about religion.

Her cheap cologne was intoxicating.
His slow tongue was shaking in reverse:
 words frequent and forgettable as waves.

She was imagining a cocktail party diamond-high above Manhattan.
He was imagining excitement like a biblical epic.

Her heart was breaking like an Arctic ice floe.
He put on his blond armor.
She felt numb as needles.
He felt like Longinus on the subway.

They went down to his basement and closed the door.
She spotted Victoria's Secret catalogues under back issues of
 Intellectual American.
He said, "I only buy them for the articles."
They watched Star Trek videos with the sound turned off.
They played old James Taylor records.

He said, "I'd like to explore the erotic aspect of this relationship."
She said, "Can it wait till the commercial?"
He said, "Have you ever read 'The Wasteland'?"
She said, "My last boyfriend took me to Hoboken for the weekend."

He drove her home on the Belt Parkway.
They stopped in the shadow of the Verrazano Bridge.
They felt like tourists in a phantom America.

He put his hand inside her blouse.
He smiled and said, "You like that, don't you?"
She felt hot and monotonous, like a country of no seasons.
She fantasized a bath and baby powder.

He had the sensation of running hard on a dark suburban street,
 feeling skinless and full of eyes.
He said, "Be my Ariadne."
Ten minutes passed big and slow like clouds.
She said, "What's an Ariadne?"

He recalled a book by Aldous Huxley: *The Genius and the Goddess.*
He began eagerly to anticipate
 the terror in the morning, the terror in the evening,
 the terror at suppertime,
an abuse so true he would touch the stars.

Now she's a whitegirl dancing braless
in his teenage basement bedroom.
Now he's a whey-faced Polack flying cross-town
towards Arabia.

CROSSING 2ND AVENUE

"what's the use of being somewhere other than
new york and return only to find new york again"

—Sheila Alson

Crossing 2nd Avenue, thinking I'd like to die for love, remembering boots on the floor above, the sea on the other side of the wall, scent of breasts in the afternoon bathroom, your skinny beauty breaking my heart and, feeling slightly sick, thinking of suicide but too afraid to survive and lose my job.

Crossing 2nd Avenue again, the storefront beauticians cracking chewing gum against gold molars, longing for some midsummer nightmare to slide down their alleys in brilliantined blue-black hair, the neighborhood roughnecks saddled up and every young girl nervous,

nervous like me waking up naked on your dirty floor again, fat clouds dissolving out high greasy windows, hungry, tired, almost in love, the bleak stairwell five flights up, all New York naked and sleeping late, indigo spring descending, its music up and down the tenements,

your neck in my teeth and light falling through trees, dream of a dead stream, its low water moving me to the end of the corridor, your long shoulder goneaway,

and we're crossing downtown just to walk around, and voices rush in like water — requiem for everything — and love drifts down around us just like rain and I'm crossing 2nd Avenue again.

THE BROOKLYN BRIDGE CLIMBS ON BONES OF BRICKLAYERS

The Brooklyn Bridge climbs on bones of bricklayers
drunk with dependencies lateral and handy,
beams broken by breathing constrained as stones,
smiles alive with ivory, red checkers in pockets,
tongues in ears on 3rd class European trains,
2nd floor landings, behind the old grocery,
spring notwithstanding, fevers vine-ripened,
crotches stippling, brilliant tulips
of tatters and charity
tatters brilliant
kitchen bathtubs brilliant
comfort of blue bathroom jars
the rank sweating the stewing and
the love-making the L train the blue hour
a last thought in the brain's multiple pathways picking bones
SPLASH

CHICAGO

It's a secret storm that is a smile; can be sardonic, can be sanguine.

If you ride the subway and watch the movie (the movie that you see when you look out the window) you are seeing the mirror that reflects the place of the place, which is your face. And what you see is Eager Plastics; stencilled cows on cemetery walls; skeletal wooden back porches of tenements housing stray languid dogs; the woman in red velvet robes selling incense; a starlet's face on a homemade billboard announcing price war; and there, behind that college kid smoking a cigarette, is a warning on a pillar: "Ronald Reagan, An Oral Danger." The train riffles the kid's hair as it passes.

There is the sign on the laundromat : No Bus Waiting Inside, that you see every day on your way to work at City Hall. And there is Frank's Unisex Hair Shop that you go to with your girlfriend, and Frank is a big fat Mexican in rust-colored slacks that droop at the knees and look like corrugated cardboard who went from sheet metal working to shampooing. And there is the time at 1:00 in the morning in summer when the kids on the block turn on the hydrant, and water runs in rivulets off their small black shoulders.

There are apartments to live in, with three other people, three or four cats, a couple of dogs and a baby. There are places for big people to work called offices, and ways to get the jobs, called patronage. There are bars to go to after work called The Boozoory and The King Midas Lounge, and the best one of all that never was, The I-Fuck-You Saloon. There are in-laws to impress with your new permanent wave, and there is seersucker to consider when shopping downtown with your sister.

There are women, bovinely hideous, who know how to throw their hair. They do it at bus stops if they think you're watching, and if you're not they'll practice. There are subjects you must remember to discuss with your fiancé, but you must never remind him of his father's workbench. There are girls to define and pursue and girls you just talk to. There is St. John of God Church where you get married and die. There is Cubs park for yuppies and Sox park for drunks. There are parties for jewelry, rubber goods and makeup. There are girls who are magnets and girls that you marry.

There are times you take a romance novel into the bath and there are times you stop dyeing your hair. There are times you spend all summer drinking whiskey sours in a pink room, and there are times you spend all winter in a bare bed waiting for a phone call. And certainly there is the time you stop collecting those postcards: that's the time of Chicago's nonvolatile memory.

HALF ANGEL, HALF LUNCH

Outside you're a big girl now,
owner of things that plug in,
safely emigrated from the old neighborhood's mothery clutch.
But inside broods that familiar kid:
big-kneed bird-legs in saddle shoes,
uselessly rouged nipples beneath a nautical shirt bought at Sears,
who watches the ex-lover sneak into evening, melting back into
 suburbia in his mother's Mercedes.

Tonight he's returned after six years,
and just for old times he's sat you down and forced you to recall
the all-night black girl beauty salons and big-gut bowling alleys
you introduced him to,
the storefront fish restaurants of the slums,
the dates at the dirty movie,
beginning with six-packs of Bud and handfuls of Ramses Extras,
continuing onto the Puerto Rican pompadour roller rink,
and ending with the cinematic swirl of his mad young kisses,
beneath the still-bright marquee of an ancient south side theatre.

His return brings a miasma of memories, most of them bad:
department store parking lot blow-jobs while passing shoppers watch;
a Bronx cheer from outside the Cozy Cafe window
in front of all your friends;
3 a.m. phone calls that upset your mother;
and breaking your tailbone skating on Fleet Street,
while he scouts the neighborhood snack shops for noontime blondes:
"Love means having to say you're sorry every five minutes," he explains.

Afterwards you watch from your third floor window:
he strolls over to the Mercedes parked in front of The Magnolia Arms
("Uptown's Classiest Halfway House"),
gives the thumbs-up to the homeless man in the undershirt
muttering on the curb,
then cowboys the car away.

Filled with feeling you pry your skinny viscera sky-wide
to let in the eternity of the evening,
batter against heaven until it gives back
all your nine-hour St. Jude novenas (patron saint of hopeless cases);
the rosaries recited desperately, breathlessly, on the City Hall toilet
to insure his affection forever;
memories of lying prostrate beneath him for weeks,
distraught from love's insomnia;
and the intense, now-gone desire you long, once again, to possess.

Look! The couples kissing on Coiler's Beach
are worshipping the first place he stood you up!
The totem pole at Bittersweet and Eden is a beacon
to the first place you slapped his face!
The whole of Chicago is a shrine to his first romantic line:
"Is that your real hair color?"

Listen! The wild night is calling.
But no, your small amens simply dissipate
noplace in particular.

ELEUSIS

1.

My mother offers me tranquilizers like a kid sharing a stash of candy. I sit down on the cot opposite her bed and watch her undress.

You should see me in the nude, she winks, I'm really cute.

Like any Anglo-Saxon I know nothing of the fungal world, but she defines for me the source of all unnatural splendor, half-exotic, half-dead.

I never suffered anything in my life like the last six and a half hours, she says. Hand me that Romilar. Listen, when we were kids we didn't have Romilar—we used the roots of a tree.

She smells of tobacco, bed sweats, bloat. She spends half her time in that bed reading romance magazines, scandal sheets, eating, coughing, spitting up. Every moment with her is another nightmare. I've just come off a week of living in an utter void of sight and sound, crescendoing with my passing out naked in The Dog Hole, a South Side bar. Now here, in this badly paneled bedroom, the long dark night of the soul is occurring spontaneously every five minutes, and I'm beginning to wonder just how a human psyche can bear witness to this kind of crustacean horror, normally buried deep within it.

By noon she's throwing her voice directly into my psyche:

I got palpitations of the brain pans, what they call it . . . It's my *harmones*! They keep gettin' more 'n' more delicate! . . . Hyperstatic, how they call it. Listen, hand me a Tranxene. You need a Prozac? I got ten right here. First put a tv dinner in.

Syllables flying off, frayed, hasty, in jerks. Talk, talk. Listen, listen. Each of my five senses a convenient conduit for her seemingly accidental tortures. The anguish of hearing thousands of ill-conjugated verbs. She exhibits that legendary tendency of the Nordic-Teutonic nature to discern the potential for torture in any situation. I have abandoned all belief in my revival. No one will find me here where invisibility is the same as failure. I wonder if anyone has noticed that I'm dead, and if so whether they've taken the trouble to mourn me.

Outside the streets are being cleaned, like on the weekend.

2.

I used to be a drunk and that made me a citizen of the world. A cut-rate parasite, welcome anywhere. The 14th Ward regulars knew they could count on me for a few drinks, sometimes even a bottle of pills depending on who I'd slept with. Back then we were so familiar. Of course I was always impeccably groomed and ready to manipulate exquisite verbal resources, launching my listeners into diverse worlds of classrooms, country clubs, funny farms, public toilets. I was also blessed with a metropolitan fame based on a complete disregard for my personal safety. I could drop in anytime through the night entrance of The Dog Hole and immediately sink into a delicious lethargy, my chloroform bottle at the ready. On my last night of freedom I had made my way through the verminous shadows

64

hunched over broken tables to the backroom, where Pete, the alderman's assistant, held forth.

Have you seen the latest acquisition? he asked, then handed me a vial containing a mixture of barley ergot and mint—the legendary *kykeon*.

Blissful is he, winked Pete, invoking the Eleusinian benediction, who has been initiated into the Holy Mysteries, who knows the end of life as well as its beginning.

Blissful is she, I answered (in accordance with the ancient and accepted rite), who has received Reason and dies with Hope.

He mixed the kykeon in a silver goblet with the tibia of a pig and handed it to me.

My first feeling was a bottomless terror. The fitful wind I'd been hearing became a vast wheel, constantly accelerating. Then the wheel became a gondola, sweeping majestically through moonlit lagoons, then an eagle careening me up, Alp over Alp, then down into the primeval forest where my soul metamorphosed into some kind of giant vegetable, an eggplant maybe. I continued as an eggplant for what felt like days even though it was only about three minutes tops. Then from the very bottom of my despair I heard a voice like a tremendous engine, full of sublime cadences, the voice of a multitude of deaths. It began as a jet of pulsating air and nerve, then crackled into a nasal whine, softened by phlegm, tinged with banality and fear. From beneath the cathedral archway of giant fern I heard:

What kinda dummy sits in a queer bar gettin' stupid drunk?

It was her. Her voice. And she was bending over me, the warm hole of her mouth the center of all roses, disgorging with every word the legion demon agents of my transformation. How had I found my way back to her plastic-covered couch? That was just the beginning. The Word made fleshy.

65

3.

The afternoon ritual: a perversion of the very idea of repetition as comfort. She stretches out across the bed to make contact with a blue box of ice cream cones, her favorite snack. Everything about her is vivid colors: the Wonder Bread bag, the little boxes of sugary breakfast cereals, the cheap striped cotton tops, and when she goes to Lulu's, the red-orange trailer across the street where she buys her milk, bread, cigarettes and Lotto, she wears a green scarf over her thin, graying pincurls. All she has to do is move, or not move, and all the horrors and ignominies of a life spent with her begin flowing again, real fast, like an Ethiopian funeral mass.

Y'know, I'm not like you, she says today and will surely say tomorrow, pulling a cone out of the box, I don't need an audience. Go get me a Kleenex.

Always at about seven o'clock we enter the second phase of everyday, like a lime-green Rambler jauntying towards inevitable disaster. The endlessly garish tv shows, the families in their big sweaters in their comfortable homes, the women well-fed, their cherry lips perfect. From the plastic-covered couch I watch the cars go by outside and begin again my fantasy of the perfect all-night diner, its fake ferns, ceiling lights and fans a beacon in the feathery night, proclaiming the comfort of whatever I want, they got.

Midnight begins with her hot breath filling the bedroom *(I got th' devil lookin' over my shoulder . . . Aw now where th'hell are them Tranxenes?)* and the sickly tv sheen moving mauve-to-violet-to-green in the living room where I lay on the couch, watching the shadows stirring as they seek form. The heady nausea accompanying the rapid succession of ideas that replaces sleep can be categorized in three ways: what I'm thinking/what I need now/who I should have been by now. And the reality: I wanted to be an angel; I have become a beast. Everything implied by the word "chance" has turned on me to reveal the depth of my mediocrity; I am, in fact, a kind of patron saint of mediocrity, a Saint Teresa of Avila pierced by the arrow of all that has been and will forevermore be Lost.

I recall the good old days when by merely going to dinner I could scandalize everyone. The good old days of "I can't run in these earrings!" Now, enthralled by oppressive thoughts that come sudden, perfect and inevitable, I can comfortably anticipate extraordinary pain the like of which the man in the street will never know. This certainty becomes the very archetype of my psyche's precise annihilation. I am a being truly transformed by the purity of complete mediocrity.

Later, just before dawn I hear, from somewhere near my ear:

The god of sleep is the same as the god of healing.

Later. Within the safety of an endless stream of thoughts the night progresses to its end mysteriously, piously, like the Canticle of the Ancient of Days.

4.

Dawn's milky light reveals only enlarged pores and the results of a recent $7 haircut. The light overflows its shafts that stripe the bathroom tiles and fuses into a single intense instantaneous feeling of eternity. Who was I before this light and what did I do and what did I think?

She's still asleep. But soon she will grow, swell and burst like a meteor—coughing, shuffling, smoking and flailing into the bathroom then back to the bed, and this halo of nostalgia for the present will disappear forever like prehistory's first lost tribe.

I go into her room, as I do every morning, to see if she's still breathing. I listen for the little "puts" of breath coming from behind her skinny lips. But today there are no little "puts." She's dead. I sit down on the cot across from her bed. I look at her hard round head, her mouth open as if she were trying to form the perfect vowel.

I sit on the cot across from her bed and watch the hours swing down to afternoon. It's amusing to wonder how long I can sit here with her body. I like having her body in this room. No one in the neighborhood knows; they are all going about their business and we are alone, just the two of us, and the memories her body has released to me. She is my new all-night diner, her body a beacon of comfort in the feathery dark. She for whom I sacrificed everything and now have nothing. No thing. Tonight we will both be able to sleep.

5.

It's the warm yellow morning of a busy day. The languid and astonished condition of giddiness replaces any memory of past unhappiness. Outside I can hear the neckbells of invisible horses. I think of the punishments I've suffered and the comfort of this new insatiable thirst for clarity. Thus I see no great danger in breaking free, despite the certainty of losing a bit of dignity: I can call any Seven-Eleven in the country and be assured they're serving strong, shiny coffee.

What I know now: Reality is the raw material for the process of personal demise as The Great Work. My ego feeds exclusively on the certainty of my immediate and eternal ruin. Like Chiron I have been mortally wounded, but through my sacrifice at the hard red hands of The Mother I am immortal and cannot die. This is my punishment. But like the hanged man, whose orgasm is not a gesture of submission but a gift from The Tree of the Knowledge of Good and Evil, I have received nothing less than ultimate Reason here, and can live on forever in purest Joy. The lost are lost by destiny, and destiny starts early and falls naturally one thing to the next like an old man's lazy game of dominoes on the summer stoop.

I speak to you now in her own flat, spent idiom: on the day you wake beyond the Pleiades, remember me to the One who lived here:

she once was a true love of mine.

THE END

Ample purple shadows between me and you,
this heart a calm palmetto grandly glamorous and tragic.
You: my favorite song, forever young and in one piece,
my own personal summer burbling up a broken flight of stairs.
The screen door slams at midnight;
invisible schoolgirls emerge from plaid like every melodrama
dreamed by a bunch of bad Mary Anns.
The bright sidewalks where spontaneous romance once occurred,
now just reminders of my poverty.
I'm really living an Oriental life now,
in a perpetual dread of saying something gauche,
wasting long days on a mossy stained mattress,
dreaming the affair between the old Andalusian sheik
and the little girl from Mecca.
Pitiful shitheads, I won't get anywhere in this world
if I don't learn to lie about everything.
Oh, will you please screw me in Cuban moonlight once again
so's I can write a few good poems?

Sharon Mesmer was born in Back-of-the-Yards, a Chicago neighbor-hood named for its proximity to the Union Stockyards. In the '80s she was active in that city's literary scene, co-founding and -editing the publications *B City* and *Letter Ex*. In 1981 she published her first chap-book, *Jayne Mansfield's Head*. Since making New York her home in 1988, she received a MacArthur Scholarship from Brooklyn College (by recommendation of Allen Ginsberg), and was a featured per-former in "Words In Your Face," the 1991 season premiere of the PBS series "Alive From Off Center." A second chapbook, *Crossing Second Avenue*, was published in Japan in 1997, coinciding with her reading tour of three cities there. During two residencies at the MacDowell Colony and one at Hawthornden Castle, Scotland, she completed her first novel, *Fly*. In 1998 she collaborated with Prix de Rome-winning composer Barbara Kolb on a libretto for the Indiana University of Pennsylvania's festival honoring the 900th birthday of Hildegarde von Bingen. Currently, she teaches fiction writing and literature at the New School in Manhattan, is a member of the miscreant collective Unbearables, and is English language editor of the Japanese literary magazine *American Book Jam*.

lingo books

Home In Three Days. Don't Wash.
Linda Smukler

little men
Kevin Killian

Tilt
Gillian McCain

No Both
Michael Gizzi

White Thought
Tom Clark

Blow
Lynn Crawford

The Letters of Mina Harker
Dodie Bellamy

Half Angel, Half Lunch
Sharon Mesmer

Series Editor: Jonathan Gams